NICOTEXT

Bla Bla Sex

DO NOT DRINK AND DRIVE & DO NOT DRINK ALCOHOL
IF YOU ARE UNDER DRINKING AGE!

...AND KIDS, REMEMBER, ALWAYS WEAR A CONDOM!

ISBN: 978-91-85449-15-6
Printed in Sweden by STC Avesta

Fredrik Colting
Carl-Johan Gadd
Cover Design by Digital Artist Johan Andersson

www.nicotext.com

Average number of times a man will ejaculate in his lifetime: 7,200.

Actual amount of semen per ejaculation: 1–2 teaspoons.

In 1995, Mo Ka Wang, a Chi Kung master in Hong Kong, lifted over 250 pounds of weight two feet off the floor with his erect penis.

There are men in Guam whose full-time job is to travel the countryside and deflower young virgins, who pay them for the privilege of having sex for the first time...

Reason: under Guam law, it is expressly forbidden for virgins to marry.

A law in Fairbanks, Alaska, does not allow moose to have sex on city streets.

In Ventura County, California, cats and dogs are not allowed to have sex without a permit.

Human testicles can increase in size by 50 percent when a man is aroused.

The average man sees five women a day he would like to sleep with.

In Hong Kong, a betrayed wife is legally allowed to kill her adulterous husband, but may only do so with her bare hands. The husband's lover, on the other hand, may be killed in any manner desired.

According to *Playboy*, the most popular sexual aid is erotic literature. (Of course, they would state that, they want to sell magazines.

The word "vanilla" comes for the Latin word 'vagina'. This is due to the Vanilla pod's resemblance to the female genitalia.

Blue balls, the term a man uses when he says his balls will explode if he doesn't have sex, is totally false.

Black women are 50 percent more likely than white women to have an orgasm when they have sex.

Minks have intercourse that lasts an average of eight hours.

The practice of autoerotic asphyxiation (temporarily suffocating or strangling yourself while masturbating) takes the lives of 250 to a thousand people each year.

The first non-pornographic movie to receive an X rating was *Midnight Cowboy*.

A devastated Englishman learned the horrible truth that his girlfriend was cheating on him - straight from his pet parrot's mouth. Chris Taylor's parrot Ziggy began squawking "Hiya, Gary" every time his girlfriend Suzy Collins's mobile phone rang.

The African Grey parrot also made kiss noises each time it heard the name Gary on television or radio. At first amused, Chris, a computer programmer, dismissed it as something the bird had picked up while watching TV. But when he snuggled up beside Suzy on the sofa in their flat in Leeds and Ziggy cried out in Suzy's voice "I love you, Gary", the cat was finally out of the bag.

Suzy, age 25, a call-center operator broke down in tears and confessed to having a four-month fling with a former colleague. She had met her lover in the flat while Ziggy looked on. Her confession ended their two-year relationship. It also led to 30-year old Chris Taylor to part company with his pet – because it kept screeching her lover's name.

Chris wasn't sorry to see Suzy go after what she had done, he said. But it really broke his heart to part with eight-year-old Ziggy which he had bought as a baby.

"I lost my girlfriend and best mate at the same time. But it was torture hearing him repeat that name Gary over and over," he said. Chris named the parrot after Ziggy Stardust, David Bowie's alter ego. The parrot had learned to mimic the line "Put on your red shoes and dance the blues!" from the Bowie song "Let's Dance".

Ziggy has since been found a new home with the help of a local parrot dealer.

A "Dork" is a whale's penis. The whales, as you might have guessed, have the world's largest penises. The blue whale is the champ, due to his size, with an eleven-foot long member that is one foot in diameter.

Average number of times a man will ejaculate from masturbation in his lifetime: 2,000.

The largest human vagina belonged to a woman who was 7'8" tall.

The earliest known illustration of a man using a condom during sexual intercourse is painted on the wall of a cave in France. It is dated between 12,000 and 15,000 years old.

Most arousing time of day/season for a man:
early morning/fall.

In Florida it is illegal for single, divorced, or widowed women to parachute on Sunday afternoons.

A nurse and two cameramen were arrested after they filmed a porn movie at the Munich beer festival on the city's famous big wheel.

The 21-year-old nurse and the two cameramen were spotted "filming sexual acts" by three Italian tourists in another carriage of the big wheel. The tourists immediately alerted the authorities, who detained the "porn actress" and the filmmakers.

The Munich police said: "The trio were spotted in the carriage with filming equipment. The 21-year-old suddenly disrobed and produced a sex toy that she began to use while the other two filmed her." The trio have been charged with public indecency.

The movie *8 mm* explored the underground porn fetish of snuffing (killing a partner after sex).

A law in Montevideo, Uruguay bans a man from having sex with any woman during her period.

Seventy-two percent of men admit to fantasizing about their workmates.

People worldwide are having sex for the first time at an average age of 17.3.

Just over a third (35 percent) say they were 16 or under when they lost their virginity.

Young people continue to have sex at an earlier age than previous generations: while the 25–34s lost their virginity at 17.9, the 21–24 year olds were 17.5 and 16–20 year olds were just 16.3.

Women are sexually active earlier than men — at 17.2 compared with 17.5.

People from Iceland are having sex younger than any other country (15.6) followed by the Germans (15.9), Swedes (16.1) and the Danes (16.1).

People in India are the oldest to lose their virginity (19.8) followed by the Vietnamese (19.6), Indonesians (19.1) and the Malaysians (19).

Voyeurism is the fetish that has increased the most in popularity, due to the information age.

The first to publish pornography was the 18th century French aristocrat and writer Marquise de Sade.

If your sex partner is covered with wet food, you're enjoying the fetish "splosh".

Man has the biggest penis size relative to body size of all the primates. There is no real biological reason why the male human penis has to have such prodigious length and girth; a thinner penis would inseminate females just as well.

It is thought that large-sized penises have evolved merely because the human female liked them so much. By mating with well-hung males, females unwittingly helped to selectively breed men with big members. Over the course of evolution, the big penis won out, much to the enjoyment of women.

Best ways to improve sexual function: quit smoking, start excercising, lose weight.

It`s illegal to have sex with a corpse anywhere in the United States.

The word "gymnasium" comes from the Greek word *gymnazein* which means to exercise naked, which often was done in ancient Greece.

A man in Sicily asked a friend to shoot him in the groin in the hope of making his ex-girlfriend feel sorry for him. Police in the central Sicilian city of Piazza Armerina said they became suspicious when the 27-year-old went to hospital with wounds from a hunting rifle's pellets in the groin area.

At first he said the wounds had been caused in a hunting accident, but later admitted he had asked a friend, 16, to shoot him in an attempt to win back the affection of his girlfriend, who had apparently left him because of his violent character. The man's wounds are expected to heal, doctors said.

The man, and the 16-year-old, had been charged in connection with the shooting. Local reports said the man's ex-girlfriend had made it clear that she never wanted to see him again.

A capon is a castrated rooster. They are said to have more tender meat when cooked and that's why they cost more.

In Maryland, it is illegal to sell condoms from vending machines with one exception: prophylactics may be dispensed from a vending machine only "in places where alcoholic beverages are sold for consumption on the premises."

Up until 1884, in the U.S., a woman could be sent to prison for denying a husband sex.

Amount of time needed for a man to regain erection:
from two minutes to two weeks.

A lot of lovemaking can unblock a stuffy nose. Sex is a natural antihistamine. It can help combat asthma and hay fever.

Vending-machine condom sales, on the other hand, are banned in such states as Hawaii, Kentucky, Massachusetts, Pennsylvania and Wisconsin. And in Texas, no one other than a "registered pharmacist" may sell condoms or other kinds of contraceptives "on the streets or other public places," not even physicians. This means that anyone — even a doctor — who tries to make a few extra bucks doing this will be severely prosecuted for the dire act of "unlawfully practicing medicine."

No one may purchase a package of condoms at a corner drugstore anywhere in Nebraska. Only physicians can sell them while practicing medicine. In Arkansas, condoms can be sold only by physicians and other medical practitioners.

Delaware allows the sale of condoms only by doctors and wholesale druggists.

Kentucky and Idaho limit condom sales to medical practitioners and licensed pharmacists, but their license to sell the items may not be hung on a wall where it can be seen by customers. Maine, on the other hand, licenses condom sellers, and the license must always be on public display.

Of course Nevada, with 35 legal bordellos, has no condom problem; the law there requires that condoms be made readily available at each brothel. The use of condoms in Nevada brothels is compulsory.

The female praying mantis eats her mate after sex.
During the act the female will hook her large arms around the
male to hold him in place and start nibbling away. The sex
drive is so strong in the male that he can continue to copulate
even if his partner gets a little peckish before he's finished.

Ecouteurism is listening to others having sex without
their consent.

In New York State a man was arrested for watching a pornographic film while driving. A police officer in an unmarked car spotted Mr. Gainey when he was driving near the police station. The officer saw that he was watching a pornographic film on a DVD screen inside his car.

The police said that anyone could easily see that the man was watching a porno movie. Even people who were walking by on the pavement could see it clearly. Imagine if a family with small children was driving behind him!

When the officer arrested Gainey, he was charged for watching a movie while driving, public displaying of offensive material and driving with a suspended license.

In Shakespeare's day, a lusty female would tuck a peeled apple under her arm then later offer it to the man she desired. The pheromone soaked "love apple" supposedly induced desire in the same way musk perfumes (which mimic our natural pheromones) do today.

The initial spurt of ejaculate travels at 28 miles per hour. By way of comparison, the world record for the 100 yard dash is 27.1 miles per hour.

Acrotomophilia occurs when you have a sexual attraction to amputees.

Eating the heart of a male partridge was the cure for impotence in ancient Babylon.

Hotels in Sioux Falls, South Dakota, are required by law to furnish their rooms with twin beds only. There should be a minimum of two feet between the beds, and it is illegal for a couple to make love on the floor between the beds.

A pig's orgasm lasts for about thirty minutes.

Linda Lovelace's husband was paid $1,250 for her role in *Deep Throat*.

Formicophila is the enjoyment of the use of insects for sexual purposes.

The oyster is usually ambisexual. It begins life as a male, then becomes a female, then changes back to being a male, then back to being female. It may go back and forth many times.

Children found hundreds of dead frogs in a fishing pond in the Dutch village of Montfort. According to frog expert H. van Buggenum from the local environment foundation the frogs paired themselves to death. Every year the hormones of the frogs and toads lead them to the so-called pairing ponds. The male frogs and toads then crawl in groups on one female. She gets stuffed underwater or gets suffocated by the weight of the enthusiastic males. The male frogs also die. This happens on the way to the pond. They get killed by a horde of their sex crazed friends.

In every pairing pond about a hundred frogs and toads die annually. "That's normal, but in this particular pond it's hundreds! That's pretty exceptional", van Buggenum says.

Plushophilia is the attraction to stuffed animals or the act of intercourse with a stuffed animal.

According to a Kinsey survey, 75 percent of men ejaculate within three minutes of penetration.

Average length of penis when not erect: 3.5 inches.

If a police officer in Coeur d'Alene, Idaho, suspects a couple is having sex inside a vehicle they must honk their horn three times, and wait two minutes before being allowed to approach the scene.

The first condoms in the U.S. were made from vulcanized rubber in the late 1880's. They were expensive, annoyingly thick and meant to be reused.

The porn star Asia Carrera boasts of an IQ over 150.

Latex fetish is the name of the fetish that involves dressing in the skin-tight material.

World's smallest vagina for an adult was 2 centimeters (or about 0,8 inches) — surgery was required for correction.

The Roman emperor Nero used to dress up young boys in his dead wife's clothes and make love to them.

A man's penis not only shrinks during cold weather but also from nonsexual excitement like when his favorite football team scores a touchdown, etc.

It was considered elegant for aristocratic ladies of the sixteenth century to let their pubic hair grow as long as possible so it could be pomaded and adorned with bows and ribbons.

The word avocado comes from the Spanish word aguacate
which is derived from the Aztec word ahuacati which
means testicle.

The Kama Sutra was written by Mallanga Vatsyayana,
who was rumored to be celibate.

Percent of men who say they masturbate: 60.

A healthy man can produce 70 million sperm everyday.
So does a guinea pig.

A law in Oblong, Illinois makes it a crime to make love while
fishing or hunting on your wedding day.

In 17th century Spain, it was illegal for anyone other than a
woman's husband to see her bare feet. A woman could freely
expose her breasts, but feet were considered sexual and had
to be covered in the presence of men other than her husband.

A drunk Thai man was bitten several times when he tried to rape an unwilling dog. Police said the 33-year-old man had been drinking heavily with friends before he tried to rape the dog.

The man was caught by police officers when residents in the area notified the police about a man walking along the street, bleeding.

After being questioned, the man told the police he noticed a brown female stray dog wagging its tail and 'acting sexy'.

When he tried to pull the dog into some tall grass near the roadside, the dog resisted. The dog bit him on his face, chest and arms. When the dog stopped biting him, the man tried to stagger home.

The man also admitted to the police that he had raped three dogs earlier while he was drunk.

The man said he got excited when he drank heavily but did not have the money to go to a prostitute.

"The Private Pleasures of John Holmes" is the only full-length film where John has sex with a man.

It's been said that Adolph Hitler was a coprophiliac, which means he had a fetish for women's feces. He also had a thing for being urinated on by women.

Largest penis in the animal kingdom: 11 feet (the blue Whale). It's the height from the court floor to the rim of a basketball hoop.

Nasophilia refers to arousal from touching, seeing, licking or sucking ar partner's nose.

Longest clitoris: recorded at 4½ inches long and 1½ inches in diameter.

The missionary position was the favorite sexual position of both modern Europeans and ancient Romans.

The typical person spends about 600 hours having sex between the ages of 20 and 70. A survey in *Cosmopolitan* magazine said that foreplay usually lasts 14 to 17 minutes for the average married couple, and that the man typically reaches orgasm after six minutes of copulation.

Every year, 11,000 Americans injure themselves while trying out bizarre sexual positions.

Forty-five percent of men would never cheat, even if it could be guaranteed they would never be caught.

Women were discouraged from having orgasms during the Middle Ages because it was thought that orgasms made women less capable of getting pregnant.

Both Indiana and Ohio have laws that prohibit male skating instructors from having sexual relations with their female students. This misdeed, called "the seduction of female students," is prosecuted as a felony. This statute apparently applies only to male teachers. It seems female skating instructors may have sex with male students.

Globally, people have had an average number of nine sex partners.

Men have had more sexual partners than women — 10.2 compared with 6.9.

The Turks have had more partners than any other country (14.5), compared with Australians (13.3), New Zealanders (13.2) and Icelanders (13).

Indians have had the fewest sexual partners (3) compared with the Chinese (3.1), the Vietnamese (3.2) and those from Hong Kong (3.7).

Almost two thirds (65 percent) of people in Hong Kong have had just one sexual partner, compared to 12 percent in Denmark, Norway, Sweden and Greece.

Foods that improve sex life: oysters, lean meat, seafood, whole grains, and wheat germ.

About 1 percent of the adult female population is able to achieve orgasm solely through breast stimulation.

The word pornography comes from combining two Greek words: Porne, meaning prostitute and graphos which means writing.

A survey conducted by Masters and Johnson in the early 1980's revealed that the third-most frequent fantasy amongst both homosexual men and women was a heterosexual encounter.

Medomalacuphobia is the fear of losing an erection.

The *Kama Sutra* details techniques on ten types of kisses, 64 different caresses, eight variations on oral sex, and 84 positions for intercourse. All in all, it describes a total of 529 sexual positions.

Marilyn Monroe, the most celebrated sex icon of the 20th century, confessed to a friend that despite her three husbands and a parade of lovers, she had never had an orgasm.

Timmie Jean Lindsey of Houston, TX became the first person to get silicone breast implants in 1962.

Femme domme — A woman who dominates her partners.

Australian scientists have found out what part of the brain is responsible for sexual attraction between people. They also found out that the bigger that part of the brain is, the faster and more intense man's excitement is.

The researchers, a group of neurophysiologists from the University of Melbourne, say that the degree of excitement depends upon the activity of the part of the brain called amygdala. This part of the brain is the size of an almond. When you feel sexual irritants, the amygdala will respond faster than any other part of the brain.

Before the researchers discovered this, it was already believed that the amygdala was responsible for attraction between animals.

After examining 45 epileptics of whom part of the brain is not working, amygdala included, it turned out that the amygdala plays a large role in the sexual experience.
The bigger the amygdala, the bigger the sexual lust. People with large parts of the amygdala not functioning were almost indifferent to sex.

Cunnilingus is the term for a woman receiving oral attention. The male equivalent is fellatio.

Forty-six percent of men claim they have never been unfaithful not even once.

In Bozeman, Montana, you can't perform any sexual acts in the front yard of any home, after sundown, and if you are nude.

It takes the sperm 2.5 seconds to travel the 3-4 inches iniside the human vagina to fertilize an egg. (On average, it takes a person 4 hours to complete a marathon.)

Endytophilia (n): desire to keep one's clothes on during lovemaking.

The desert rat makes the rabbit look a little useless in the Don Juan stakes. The desert rat can have sex up to 120 times an hour.

A Helena, Montana law states that a woman cannot dance on a saloon table unless her clothing weighs more than three pounds, two ounces.

In Tibet, many years ago, the law required all women to prostitute themselves. This was seen as a way to gain sexual experience prior to marriage.

Dishabiliophobia is the fear of undressing in front of someone.

The T'ang Dynasty Empress Wu Hu passed a special law concerning oral sex. She felt that a woman pleasuring a man represented the supremacy of the male over the female. Therefore, she insisted all visiting male dignitaries show their respect by pleasuring her orally when meeting. The empress would throw open her robe and her guest would kneel before her and kiss her genitals.

In a recent survey of women who use vibrators for sexual relief, eight out ten stated they do not insert the vibrator inside them, they use it on the outside of the clitoris to achieve orgasm.

Average length of a human penis when erect: 5.1 inches.

Thickness of super-thin condoms: .05 mm. (Thickness of plastic wrap: .012 mm.)

Clinton, Oklahoma, has a law against masturbating while watching two people having sex in a car.

Cold showers do not dampen overactive libidos.
On the contrary, they stimulate your sex drive. An English study, undertaken for thrombosis research, found cold showers improved circulation, strengthened the immune system, and led to a heightened sex drive. The cold water appears to increase testosterone levels in men and estrogen levels in women.

Hotel owners in Hastings, Nebraska are required by law to provide a clean, white cotton nightshirt to each guest. According to the law, no couple may have sex unless they are wearing the nightshirts.

At the beginning of the 16th century, Rome had more registered prostitutes, proportionately, than Venice. Rome had 6,800 out of total population of 90,000; Venice had 11,654 out of 300,000.

Given today's average frequency of sexual intercourse, it would take the typical American couple more than four years to try every one of the 529 positions described in the *Kama Sutra*.

A medical study conducted in Pennsylvania showed that people who have sex once or twice a week have their immune systems boosted slightly.

Playboy was the first adult magazine for the mainstream market.

Average number of erections during the night: nine.

Oculolinctus is a fetish whereby people are sexually aroused by licking a partner's eyeball. A word of caution if you want to try this: oral herpes can be transferred to the eye.

Any couple making out inside a vehicle, and accidentally sounding the horn during their lustful act, may be taken to jail according to a Liberty Corner, New Jersey law.

Sperm life: 2 1/2 months (from development to ejaculation). (Shelf life of a Hostess Twinkie: seven years.)

The first known uses of condoms in Europe date back to the 1660's.

Sex involving feces is called scat.

A rampant rhinoceros gave a group of visitors a glimpse of nature in the raw at a British safari park when he tried to have sex with their car.

Sharka, a two-ton white rhino, got amorous with Dave Alsop's car when he stopped with three friends to take pictures of the animal mating with his partner Trixie at the West Midland Safari Park.

The 12-year-old rhino tried to mount the Renault Laguna from the side, denting the doors and ripping off the wing mirrors before Dave drove away with a puffing Sharka in pursuit.

"He was a big boy and obviously aroused," Mr Alsop said. "He sidled up against us. The next thing I know he's banging away at the car and it's rocking like hell."

A spokeswoman for the park, says "rhinos are not particularly intelligent animals". However, Sharka was a hit with the female rhinos and had fathered two calves in the last five years.

"He's got a bit of a reputation this lad and he was obviously at it again," she added.

Semen contains small amounts of more than thirty elements, including fructose, ascorbic acid, cholesterol, creatine, citric acid, lactic acid, nitrogen, vitamin B12, and various salts and enzymes.

During lunch breaks in Carlsbad, New Mexico, no couple should engage in a sexual act while parked in their vehicle, unless their car has curtains.

Thirty percent of women over the age of 80 still have sexual intercourse with their spouses or boyfriends.

Turkeys can reproduce without having sex.
It's called parthenogenesis.

Porn director Gregory Hippolyte directed a video for Britney Spears.

A vibrating sex toy was mistaken for a bomb. The entire Mackay Airport in Queensland, Australia, was closed down for nearly an hour because of it.

The alarm was raised by cafeteria manager Lynne Bryant, whose staff was cleaning the tables when they noticed a strange humming noise coming from a rubbish bin.

Lynne Bryant said: "It was rather disconcerting when the rubbish bin started humming furiously. We called security and the next minute everybody was being evacuated while they checked it out."

The police spokeswoman said: "Another two flights were expected to land at that stage but alternate arrangements were made for the passengers to collect their luggage away from the terminal," the spokeswoman said.

While the police was calling in bomb experts, a passenger came forwards to identify the contents of the package. The unidentified passenger forgot his bag after dinner.

The adult movie *The Italian Stallion* starred Sylvester Stallone.

Sacofricosis, is the practice of cutting a hole in the bottom of a front pants pocket in order to masturbate in public with less risk of detection.

Among sexually active adults, lesbians have the lowest incidence of sexually transmitted diseases.

In general, women who are housewives are more faithful than working women.

The same chemical responsible for the ecstatic highs of love and sexual attraction, phenylethylamine, is also found in chocolate.

Sperm banks keep their donor semen at approximately -321 degrees Fahrenheit. At that temperature, it could be kept indefinitely.

In Nevada sex without a condom is considered illegal.

Women with a Ph.D. are twice as likely to be interested in a one-night stand than those with only a Bachelor's degree.

Fellatio ranks as the number one sexual act desired by heterosexual men.

Whipped cream, ice-cream and chocolate spread... are the three foods 30 percent of women would most like to lick off their partner's body.

A U.S. News and World Report poll found 50 percent agree that it is better to remain a virgin until you marry, and 39 percent felt it's better to have sex with a few different partners before settling down to marry.

Snakes have two sex organs.

Hybristophilia is arousal derived by having sex with people who have committed crimes.

In Cleveland, Ohio women are not allowed to wear patent-leather shoes.

The largest natural human penis recorded was 11 inches long.

According to the Kinsey Institute, masturbation is more common among white-collar workers than blue-collar workers.

In the state of Washington there is a law against having sex with a virgin under any circumstances (including the wedding night).

In Santa Cruz, Bolivia, it is illegal for a man to have sex with a woman and her daughter at the same time.

Mosquitoes, which mate in the air perform a sex act that lasts only two seconds.

Axillism: is the act of using of the armpit for sex.

An American judge is facing unemployment after using
a sex toy, a penis pump, in court.

The 57-year-old judge, Donald Thompson, was seen doing
something with his hands under his robes.

A police officer says he saw the judge pumping a tube
between his legs. Other witnesses said they heard
hissing noises.

Lisa Foster, a court clerk, says she saw the judge's penis at
least 20 times because of his clumsy maneuverings.

The Creek County, Oklahoma judge said the sex toy, used to
extend the penis, was a "gag gift" from a friend.

The district attorney wants Donald Thompson sacked for his
bad taste.

This judge is probably better off finding another career.
A job that comes with a name tag and a broom might
suit him better.

In Cali, Colombia, a woman may only have sex with her husband, and the first time this happens, her mother must be in the room to witness the act.

The male tick doesn't have a penis. Instead, he uses his nose to sniff out the female's vagina. Once he's made it large enough by poking his nose around, he turns round and deposits his semen.

According to *Penthouse* magazine, more women complain about infrequent sex than men do.

Sex is a beauty treatment. Scientific tests find that when women make love they produce amounts of the hormone estrogen, which makes hair shine and skin smooth.

In Florida, having sexual relations with a porcupine is illegal.

Sex education was first introduced into English schools in 1889.

Male bats have the highest rate of homosexuality of any mammal.

According to the *Kama Sutra*, a mixture of camel's milk and honey will keep a man erect night and day.

The only acceptable sexual position in Washington D.C. is the missionary position. Any other sexual position is considered illegal.

People with compulsive or pathological sexual behavior have a 12-step program available to them through SLAA, the Sex and Love Addicts Anonymous.

A parthenologist is someone who specializes in the study of virgins and virginity.

It's a crime in London to have sex on a parked motorcycle.

It is illegal for a man and woman to have sex "on the steps of any church after the sun goes down" in Birmingham, England.

Globally, 44 percent of all adults claim to be happy with their sex lives and 45 percent say they are open minded when it comes to sex.

Men are the least satisfied with how often they have sex. Forty-one percent want it more frequently compared to just 29 percent of women.

Almost four in 10 people worldwide (39 percent) like to be inspired and are looking for new ideas about sex, while only 7 percent believe their sex life is monotonous.

Lovers in Belgium (57 percent) and Poland (56 percent) top the contentment chart, while the Chinese (22 percent) and Japanese (24 percent) are the least happy.

Scandinavians are the least satisfied with the amount of sex they have, with both the Norwegians (53 percent) and the Swedes (52 percent) wishing they had sex more frequently.

Fifty-four percent of all men say they masturbate at least once a day.

No woman may go out in public without wearing a corset in Norfolk, Virginia.

Odors that increase blood flow to the penis: lavender, licorice, chocolate, doughnuts, and pumpkin pie.

In Kingsville, Texas, there is a law against two pigs having sex on the city's airport property.

More Americans lose their virginity in June than in any other month (must be all those weddings and prom nights).

An unobstructed penis is capable of shooting semen anywhere from 12 to 24 inches.

Micropenis is a rare disorder where the afflicted suffers from an unusually small penis, roughly .75 to one inch long when erect.

"Venus observa" is the technical term for the "missionary position."

Longest labia minora: some African tribal women enlarge their labias to seven inches in length.

A Tremonton, Utah law states that no woman is allowed to have sex with a man while riding in an ambulance. In addition to normal charges, the woman's name will be published in the local newspaper. The man does not receive any punishment.

The most recorded orgasms in an hour by researchers at the Center for Marital and Sexual Studies in Long Beach, California, was 134 by one female and sixteen for a male.

The average person, over a lifetime,
spends two weeks kissing.

In Connorsville, Wisconsin no man shall fire a gun
while his female partner is having a sexual orgasm.

It is common for men to wake up with "morning wood,"
a name for a morning erection.

Topless saleswomen are legal in Liverpool, England — but only in tropical fish stores.

The typical lovemaking session averages 15 minutes in length.

John Holme's autobiography is titled *Porn King*.

In Bakersfield, California, anyone having intercourse with Satan must use a condom.

In France, art covers a multitude of sins. A French hooker in the 18th century could avoid punishment if she agreed to join an opera company.

A man will ejaculate approximately 18 quarts of semen, containing half a trillion sperm, in his lifetime.

A small flaccid penis generally has a greater percentage increase during erection than a larger flaccid penis.

The Asiatic Huns punished convicted male rapists and adulterers with castration. Female adulterers were merely cut in two.

In Cattle Creek, Colorado, it's illegal for any couple, even a man and wife, to have sex while bathing "in any lake, river or stream."

There's actually a law on the books in NewCastle, Wyoming that specifically bans couples from having sex while standing inside a store's walk-in meat freezer.

In the original Grimm fairy tale, *Sleeping Beauty*, the Prince rapes her while she sleeps and then leaves before she wakes up.

There's a word for the fear of seeing, thinking about, or having an erect penis. It's called ithyphallophobia.

XXXChurch.com is the name of a Christian anti-porn Web site.

Wyoming's Grand Tetons mountain range literally means "Big Tits".

There is, in fact, an Illinois law that prohibits a number of things — one of which is a public erection, another is nude dancing. The prohibition against the public erection has never been challenged in the Supreme Court, but the prohibition against nude dancing has.

Among primates, man has the largest and thickest penis.

The average shelf-life of a latex condom is about two years.

As late as 1990, several states still had laws against heterosexual fellatio or cunnilingus (oral sex), anal sex and the use of dildos: Idaho, Utah, Arizona, Oklahoma, Minnesota, Louisiana, Mississippi, Alabama, Georgia, Florida, South Carolina, North Carolina, Virginia, Maryland, Massachusetts, Rhode Island and Washington D.C.

Not long ago a man was sentenced in Georgia to five years in prison for engaging in oral sex. With his wife. With her consent. In their home. His predicament has reportedly been quite a source of amusement to other inmates.

Masturbation is outlawed in French Guiana because of the "danger it presents to the masturbator." The law notes that such a physical act "is recognized as a common cause of insanity."

The more sex you have, the more you will be offered. The sexually active body gives off greater quantities of chemicals called pheromones. These subtle sex perfumes drive the opposite sex crazy!

Anasteemaphilia: The attraction to a person because of a difference in height.

Sex burns 360 calories per hour.

The French tickler was invented by a Tibetan monk.

A law in the town of Doha, Qatar states that if a naked woman is surprised by a man while either changing or bathing, she must first cover up her face, rather than her body.

White women and those women with a college degree, when asked, said they were more receptive to anal sex than women without college educations.

Sex

In the town of Alexandria, Minnesota, a man cannot make love to his wife with the smell of garlic, sardines, or onions on his breath. If his wife so requests, the law mandates that he must brush his teeth.

In Krakow, Poland it's not only a crime to have sex with animals, but three-time offenders are shot in the head.

The original representation of Cupid by the Greeks was that of a beautiful young boy whose naked form was considered to be the embodiment of sexual love.

Among transsexuals who choose sex-change operations, females who elect to become males are reportedly happier and better adjusted after the procedure than males who elect to become female.

According to a survey of sex shop owners, cherry is the most popular flavor of edible underwear.

Approximately one out of every two hundred women is born with an extra nipple.

Somebody actually timed a rattlesnake mating session that lasted 22.75 hours.

Gentle, relaxed lovemaking reduces your chances of suffering dermatitis, skin rashes and blemishes. The sweat produced cleanses the pores and makes your skin glow.

Kissing each day will keep the dentist away. Kissing encourages saliva to wash food from the teeth and lowers the level of the acid that causes decay, preventing plaque build-up.

Sex is biochemically no different from eating large quantities of chocolate.

Graham crackers were once believed (and in some cases used) to reduce sexual arousal and desire.

Eighty-five percent of men who die of heart attacks during intercourse are found to have been cheating on their wives.

Siderodromophilia: The arousal from riding in trains.

A phony "educational" documentary filled with sex footage is called "a white coater".

Egyptians inserted stones into their vagina to prevent pregnancy. (It worked kind of like the modern IUD by preventing implantation).

Sex

After eight years of childless marriage, a 30-year old wife and 36-year old husband from Germany went to a fertility clinic to find out why there were still childless. The cause of their trouble to conceive was an unexpected one.

They visited a fertility clinic and the doctors ran some tests which indicated they shouldn't have any trouble conceiving a child.

A spokesman for the clinic said: "When we asked them how often they had had sex, they looked blank, and said: "What do you mean?"

"We are not talking about retarded people here, but a couple who were brought up in a religious environment who were simply unaware, after eight years of marriage, of the physical requirements necessary to procreate."

The couple now knows about the birds and the bees, and with some luck and diligent application of their new-found knowledge they will finally have a child.

The vow of a Roman vestal virgin lasted thirty years.
If she engaged in sex before then, she was punished
by being buried alive.

In Alabama, it`s against the law for a man to seduce "a chaste
woman by means of temptation, deception, arts, flattery or a
promise of marriage."

Forty-four percent of adults worldwide have had a one-night stand. Twenty-two percent claiming to have had an extra marital affair.

Almost a quarter (23 percent) of adults around the world have had sex using vibrators and 20 percent have used masks, blindfolds or other forms of bondage.

Women are more likely to have used vibrators when having sex than men - 24 percent compared to 21 percent.

The Turks top the charts when it comes to having had an extramarital affair (58 percent) while the Norwegians (70 percent), Finns, New Zealanders and Swedes (64 percent) are ahead of the game when it comes to a one night stand.

Sex using vibrators is most common in Australia (46 percent) and in the USA (45 percent).

In 2004, a sex toy was introduced that does not require batteries: it connects to a USB port.

Forty-one percent of men say they feel guilty masturbating as often as they do.

Around the time of the Roman Empire, a Germanic tribe called the Teutons would punish prostitutes by suffocating them in excrement.

The Romans would crush a first-time rapist's gonads between two stones.

About 8.5 billion condoms are produced every year worldwide.

A man's beard grows fastest when he anticipates sex.

Sex is one of the safest sports you can take up (if you use a condom). It stretches and tones up just about every muscle in the body.

Sex is an instant cure for mild depression. It releases endorphins into the bloodstream, produces a sense of euphoria and leaves you with a feeling of well-being.

Pony was the first shoe brand to hire a porn star for endorsements.

In Middle Eastern Islamic countries it is not only a sin, but a crime as well, to eat a lamb that you've had sex with.

Emetophilia is the arousal from vomit or vomiting.

The record for most orgasms: 134 in one hour for a woman and 16 for a man.

Sex actually relieves headaches. A lovemaking session can release the tension that restricts blood vessels in the brain.

The Japanese geishas would not perform fellatio because it was considered demeaning for the cultured to do so.

White people are more likely to cheat on their spouses than any other racial group according to American private detectives. In a study of 1722 cases of "marital disloyalty", they also discovered that men are more likely to have affairs in the month of December, while women prefer July.

One in five men said they would make a pass at their best friend's girlfriend, but only one out of thirty women said they would do the same.

Cost of a year's supply of condoms: $100.

In Indiana, mustaches are illegal if the bearer has a "tendency to habitually kiss other humans."

Many ancient sexual positions are physically impossible for most people.

Three out of a thousand men (0.3 percent) are well-endowed enough to fellate (blow) themselves to orgasm.

The first "official" vasectomy was performed in 1893.

The chimpanzee holds the record for the quickest mammal sexual intercourse session at an average of three seconds.

Agalmatophilia is an attraction to statues or mannequins.

The first gay porn films appeared in the early 20th century.

A "buckle bunny" is a woman who goes to rodeos with the intent of having sex with a rodeo cowboy.

The word "fuck" is actually an acronym. It dates back to the good old days, when England was severely underpopulated due to the usual combination of fire/war/plague, and the king issued an official order to... well, fuck, to replenish the population.

Hence the phrase "Fornicate Under Command of the King" passed into everyday language.

Fourteen percent of Americans have skinny-dipped with a member of the opposite sex at least once.

In ancient Greece, women would expose their vaginas to ward off storms at sea.

Two of the main causes of temporary impotence are tight pants and prolonged cigarette smoking.

In earlier times, virginity on one's wedding night was of the greatest importance. To prove that the bride was a virgin, it was customary that the couple would display the bloodstained bedsheet for all to see once the wedding was consummated.

In China, women are prohibited from walking around a hotel room in the nude. A woman may be naked only while in the bathroom.

During the 1920's, it was believed that jazz music caused one to permanently lose his sexual inhibitions. It was often banned in many cities. One private company went as far as to sell the elites "jazz proof" furniture.

According to the Kinsey Institute, half of the men raised on farms have had a sexual encounter with an animal.

The Egyptian 'Ankh' is actually a symbol representing the male and female sex organs.

The first couple to be shown in bed together on prime time television were Fred and Wilma Flintstone.

Crematistophilia is the arousal from being charged for sex.

An adult gorilla's penis is only two inches long.

Sixty percent of women say they did not enjoy sex their first time.

Honking of car horns for a couple that just got married is an old superstition to insure great sex.

The word "sex" was coined in 1382.

According to recent surveys, the man is the most likely partner to be tied up during sex.

The Mambas of New Hebrides wrap their penises in yards and yards of cloth, making them look up to 17 inches long.

Dacryphilia is the arousal from seeing tears in the eyes of a partner.

The penis of a dragonfly is shaped like a shovel and has the ability to scoop out a male rival's semen.

If you were a female citizen of the church of Aphrodite in Paphos, Cyprus, before you could be married you had to prostitute yourself to a stranger.

Horny, a small town in North Carolina has banned all massage parlors.

A typical orgasm lasts from three to ten seconds, with contractions occurring every 0.8 seconds for both men and women.

In Medieval France unfaithful wives were made to chase a chicken through town while naked.

In the state of Utah, sex with an animal - unless performed for profit - is not considered sodomy and therefore is legal.

In ancient Greece and Rome, dildos were made out of animal horns, gold, silver, ivory and glass.

Menstrual cramps have been known, in rare cases, to induce orgasms.

Globally, the top three sexual enhancers are pornography (41 percent), massage oils (31 percent) and lubricants (30 percent).

More than one in five adults have used a vibrator (22 percent) and they are more popular with women than men - 26 percent compared to 19 percent.

A third of women (33 percent) have used massage oils to spice things up a little while men prefer pornography (49 percent).

The Thais use pornography more than any other country (62 percent), lubricants are most popular in New Zealand (60 percent) and pleasure enhancing condoms get the thumbs up from half of all Bulgarians.

Casanova boasted that he made love to the same woman twelve times in one day.

In the state of Texas it is a misdemeanor if two men engage in oral and/or anal sex; it is considered sodomy. The same law does not apply to men and women engaging in the same activity with each other.

The black widow spider eats her mate during or after sex.

Fourteen percent of all males did not enjoy sex the first time.

While nudity was considered commonplace to the ancient Greeks, a man was considered indecent if he had an exposed erection.

The early Christian church forbade couples from having sex on Wednesdays, Fridays and of course, Sundays.

Both humans and porpoises have one social sex practice in common – group sex.

Males, on average, think about sex every seven seconds.

The ejaculate from a bull's single ejaculation, if fully extended, could be used to inseminate 300 cows.

Trampling involves standing on a person as he/she orgasms.

Am Abend was the name of Europe's first porn movie.

In Pompeii, a special law was directed at prostitutes. They had to dye their hair blue, red or yellow in order to be able to work.

Cleopatra invented her own diaphragm from camel's poop.

Women who read romance novels have sex twice as often as those who don't.

Six thousand years ago, Egyptians, the first to punish sex crimes with castration, would completely castrate a male convicted of rape. A women found guilty of adultery would find herself without a nose, the idea being that without a nose, it would be harder for her to find someone with which she could share her adulterous ways.

Dendrophilia is a sexual attraction to trees.

During the Middle Ages, if you were guilty of bestiality you`d be burned at the stake, along with the other party to your crime.

Seventy percent of women would rather have chocolate than sex. (Poll taken in 1995 by a popular women's magazine.)

A person with both male and female genitalia is called a hermaphrodite.

Sex is the safest tranquilizer in the world. It is ten times more effective than valium!

One of the reasons male deer rub their antlers on a tree or the ground is to masturbate.

Upskirt involves looking up a woman's skirt.

Rabbits have been the emblem of fertility because of their well-known talents for multiplying.

The hymen is named after the Greek god Hymenaeus - the God of marriage and weddings.

Australian women have sex on the first date more than women the same age in the U.S. and Canada.

While not as extreme as the ancient Israelite punishment for adultery (stoning), Greek men still had their fair share of discomfort if they were caught: their pubic hair was removed and a large radish was shoved up their rectum.

In Nepal, Bangladesh and Macao it is against the law to view movies containing either simulated lovemaking or the pubic area of men and women. The law also does not allow kisses to be shown in any film that includes actors from these three countries.

Under Lebanese law, men are legally allowed to have sex with animals, but the animals must be female (no word on if the animals must have a permit). Having sexual relations with a male animal, however, is expressly forbidden.

In the town of Merryville, Missouri, women are prohibited from wearing corsets because "the privilege of admiring the curvaceous, unencumbered body of a young woman should not be denied to the normal, red-blooded American male."

Wild animals, as a rule, don't get Venereal Disease, although otters can get herpes.

The frequency with which a woman has orgasms during her sleep actually increases as she ages during her childbearing years.

Being sexually submissive to a giant woman is called giantess fetish.

The female bedbug has no sexual opening. To get around this dilemma, the male uses his curved penis to drill a vagina into the female.

Forty percent of women have said they had an orgasm while dreaming about sex. That number is 80 percent for men.

It was during the Victorian era that the formerly nude Cupid was redesigned as wearing a skirt.

It's illegal anywhere in the U.S. to use any live, endangered species, except insects, in public or private sexual displays, shows or exhibits depicting cross-species sex.

In Mississippi, S&M is against the law. Really. "The depiction or description of flagellation or torture by or upon a person who is nude or in undergarments or in a bizarre or revealing costume for the purpose of sexual gratification (is outlawed)."

On average, 20 percent of women who live with their boyfriends have another sex partner.

According to *Playboy*, more women talk dirty during sex than men.

Studies have proven that it's harder to tell a convincing lie to someone you find sexually attractive.

During orgasm, the heart averages 140 beats per minute.

Koalas, iguanas, and Komodo dragons all have forked penises (split in two).

Studies have shown that men become sexually aroused nearly every time they dream.

In Oxford, Ohio, it`s illegal for a woman to strip off her clothing while standing in front of a man`s picture.

Women say that the part of a man's body that they admire the most is his buttocks.

A pig's penis is shaped like a corkscrew

An interesting excerpt from Kentucky state legislation:
"No female shall appear in a bathing suit on any highway
within this state unless she be escorted by at least two
officers or unless she be armed with a club."

In the 'Motor City' of Detroit, couples are not allowed to make
love in an automobile unless the act takes place while the
vehicle is parked on the couple`s own property.

It is actually illegal for any member of the Nevada legislature to conduct official business wearing a penis costume while the legislature is in session.

The first known contraceptive was crocodile dung, used by the Egyptians in 2,000 B.C. It was replaced with elephant droppings when they realized it wouldn't work.

Hamsters can have sex seventy-five times a day.

Egypt has a law on its books prohibiting a woman from bellydancing unless her navel is covered up with gauze.

The usual result of ingesting Spanish Fly is vomiting.

An 18th century prostitute could be spared punishment if she were willing to join the opera.

Four percent of American women own no undergarments.

Couples who stare into each other's eyes for more than a minute will end up fighting or having sex according to a U.S. study.

In Romboch, Virginia, it is illegal to engage in sexual activity with the lights on.

The strongest muscle in the body is the tongue.

Harvard Medical School researchers found only 1 percent of heart attacks are triggered by sex, 10 percent caused by jumping out of bed.

There is a town in Newfoundland, Canada called Dildo.

The world's greatest lover was King Mongut of Siam. He had 9,000 wives. Before dying of syphilis, he was quoted saying he only loved the first 700.

Men in the Caramoja tribe of northern Uganda tie a weight on the end of their penises to elongate them sometimes to such a degree that the men literally have to knot them up.

Globally, people are having sex an average of 103 times a year, with men (104) having sex more often than women (101).

35–44 year olds are having the most sex - 112 times compared to just 90 times for 16–20 year olds and 108 times for 25–34 year olds.

One in five adults have sex 3–4 times a week and 5 percent have sex once a day.

The Greeks top the league at 138 times a year, closely followed by the Croatians (134), Serbian Montenegrins (128) and the Bulgarians (127).

Lovers in Japan are the least amorous, having sex just 45 times a year. Nations among the least sexually active include Singapore (73), India (75) and Indonesia (77).

In general, the taste of a man's semen varies with his diet.
– Some say that the alkaline-based foods (fish and some meats) produce a buttery or fishy taste.
– Dairy products can create a foul taste.
– The taste of semen after eating asparagus is said to be the foulest.
– ACIDIC FRUITS AND ALCOHOL (EXCEPT PROCESSED LIQUORS) GIVE IT A PLEASANT AND SUGARY TASTE.
– Examples: oranges, mangos, kiwi, lemons, grapefruit, limes, Labatt Blue, Honey Brown.
– Drinking a Corona with lime is double the fun.

Smallest natural human penis recorded: 5/8 of an inch.

The sperm of a mouse is longer than the sperm
of an elephant.

Average speed of a human ejaculation: 28 miles per hour.
(Average speed of a city bus: 25 miles per hour.)

A survey shows that 56 percent of workers have had sex at work, and that the boss's desk is the most popular place for action!

It takes a sperm one hour to swim seven inches.

It's illegal in Minnesota for a man to have sex with a live fish (is it OK for a woman?).

Passionate kissing is banned in Sorocaba, Brazil.

**Average number of calories in a teaspoon of semen: 7.
(Average number of calories in a can of Dr. Pepper: 150)**

Semen is the most common body fluid found in hotel rooms.

The left testicle usually hangs lower than the right for right-handed men. The opposite is true for lefties.

According to the Kinsey Report (1953), 15 percent of the female population was capable of multiple orgasms.

Average depth of a vagina: between three to six inches.

Everyday, 200 million couples around the world have sex, which is about over 2,000 couples at any given moment.

Humans and dolphins are the only species that have sex for pleasure.

People who enjoy the sexual conquest of obese men/women are called 'chubby chasers'.

The penalty for masturbation in Indonesia is decapitation.

Thickness of the average condom: .07 mm.

The human brain cannot tell the difference between a sneeze and an orgasm.

It is illegal for anyone under the age of 18 to pose for a pornographic magazine, movie or Web site in the USA.

When Viagra became available, operators of Nevada brothels reported that business "shot up" about 20 percent.

The male fetus is capable of attaining an erection during the last trimester.

Thirty-five percent of men are unhappy with the size of their... you know.

Oneirogmophobia is the fear of wet dreams.

Longest recorded pubic hair: 28 inches (71.12 cm) long.

Male and female rats may have sex twenty times a day.

Men are six times more likely than women to peruse sexually explicit material on the Internet.

Women who respond to sex surveys in magazines have had five times as many lovers as non-respondents.

For every "normal" Web page, there are five porn pages.

Today, Japan leads the world in condom use. Like cosmetics, they're sold door to door, by women.

Most turkeys and giraffes are bisexual.

Older participants portraying younger people is called age play.

Simulating a penis with a firearm is called gun fetish.

Studies show that, for some unknown reason, the higher the level of education, the more men tend to have wet dreams.

The term for people with bug-squashing fetish is crusher freaks.

Besides the genitals and the breasts, the inner nose is the only other body part that routinely swells during intercourse.

Exhibitionists are most likely to be married men.

The raccoon penis bone is used as charms in the American South and Middle East to boost sexual powers, profess one's love for another and bring luck to gamblers when folded into a bill.

It's said that the penis bones of the raccoon are prized for being disproportionately large compared with the size of a raccoon's body. Their bones have the same size as a bear.

Taco Bell changed the Chilito's name to the Chili Cheese Burrito, only after discovering that "chilito" was a derogatory slang term in Spanish that means "small penis."

Harry Stevens became the world's oldest groom at 103 when he married 84 year old Thelma Lucas at the Caravilla Retirement Home in Wisconsin on December 3, 1984.

According to *The Solitary Vice*, a book for doctors that came out in the 1890s, women who masturbate tend to eat a lot of foods containing mustard and vinegar.

Largest breasts: 44-pound breasts measuring 33 inches in circumference.

The G-spot is named for Dr. Ernest Grafenberg.

The most common place for adults to have sex outside their bedroom is in the car (50 percent followed by toilets (39 percent), parent's bedroom (36 percent) and the park (31 percent).

Fifty-six percent of people have had sex at work, with one in ten saying they've had sex at school - and 2 percent have joined the mile high club.

Just over a third (34 percent) of 16–20 year olds favour the car compared to 69 percent of 45–55 year olds.

More than eight in ten Italians (82 percent) have had sex in the car, while the Australians top the league for having sex in the park (54 percent).

Americans and Canadians lead the way for favouring sex in front of a camera (both 21 percent) while 22 percent of Turks have indulged in extra curricular activity at school.

The origin of the word "penis" is Latin, meaning "tail."

The clinical term for a hairy buttocks is "daysypgal."

The penguin only has one, single orgasm in a year.

Average total amount of lifetime ejaculate: Fourteen gallons. (Average amount of water it takes to fill a bathtub: 35 gallons.)

Anorgasmy is the clinical term for the inability to achieve orgasm.

"It drives technology" has often been said about pornography in media statements.

The first automatic vibrator was invented in 1869 and was steam powered. It was used to treat female disorders.

It is ancient legend that Cleopatra of the Nile had two orgasms a day.

The scientific name for the study of kissing is philematology. Philamamania is the compulsion to kiss, and a philemato-phobe is one who dislikes kissing.

In 1886, a French woman was recorded with ten individual breasts.

In America, hundreds of thousands of circumcised foreskins have been sold to bio-research laboratories.

According to the Hite Report, candles are the artificial device used more frequently by women when masturbating.

In many cultures, an unmarried woman is considered a virgin, even if she's a prostitute. It's only after marriage that she loses her virginity.

The longest engagement was sixty-seven years, according to the Guinness Book of World Records. The happy couple finally wed at age 82!

The vagina and the eye are self-cleaning organs.

The rhinoceros has a penis about two feet long.

According to a U.S. market research firm, the most common American bra size is currently 36C, up from 1991 when it was 34B.

Taphephilia is the arousal from being buried alive.

Humans, fish and porpoises share a common sexual
practice - fellatio.

The average bra is designed to last for only 180 days of use.

The first public strip-tease dance was performed in Paris
in 1894.

An Oklahoma state representative once proposed a bill requiring that a man explain the dangers of pregnancy and obtain a woman`s written consent before the two could legally engage in sexual intercourse. It didn't pass.

The most successful X-rated movie of all time is *Deep Throat*. It cost approximately $25,000 to make (according to the FBI) and has earned more than $600 million.

Napoleon's penis was sold to an American Urologist for $40,000

In earlier times, masturbation was believed to lead to blindness, madness, sudden death and other unpleasant diseases. Present research, however, shows no connection.

In Ames, Iowa a husband may not take more than three gulps of beer while lying in bed with his wife.

Authorities in Harrisburg, Pennsylvania passed a special piece of legislation governing sexual activities in the toll-collection booths on the Pennsylvania Turnpike. The law, which pertains only to female toll collectors, prohibits them from engaging in sex with a truck driver in the confines of a booth. Any woman violating this law will be fired for "behavior unbecoming an employee." (If for any reason the transgressor is later reinstated, she won`t be allowed back pay.)

Ancient Greeks admired the small firm penis, and considered the large member aesthetically unappealing.

According to one source, there are about 1,000 recognized slang words for "vagina."

The Netherlands has the lowest incidence of teen pregnancies, abortions and sexually transmitted diseases among Western nations.

The average person in their lifetime will spend an estimated 20,160 minutes kissing.

The female blue whale has the largetst vagina on the planet with a length of 6 to 8 feet.

At age seventy, 73 percent of men are still potent.

Males under the age of forty are typically able to achieve an erection in less than ten seconds.

A study of pet owners found that 66 percent claimed they allowed their pets to remain in the bedroom during intercourse.

In 1609, a doctor named Wecker found a corpse in Bologna with two penises.

People of the Hottentot tribe have buttocks that each can be two or three feet long.

"Scrump" is archaic slang for "the sexual act." Ben Franklin referred to prostitutes as "scrumpets."

A female orgasm is a powerful painkiller (because of the release of endorphins), so headaches are in fact a bad excuse not to have sex.

When men of the Walibri tribe of central Australia greet each other, they shake penises instead of hands.

The romantic Canadian porcupines kiss one another on the lips.

Having an orgasm relieves menstrual cramps because the vigorous muscle action moves blood and other fluids away from congested organs.

Experts insist that the average person falls in love seven times before marriage.

The modern psychiatric definition of nymphomaniac is a woman who cannot experience sexual satisfaction regardless of the number of orgasms or partners she has.

In Willowdale, Oregon, no man may curse while having sex with his wife.

Longest recorded orgasm: 43 seconds with 25 consecutive contractions.

Boys and girls, men and women. In case you payed more attention to the pictures of the reproduction organs than the teacher in sex ed,

here's a short recap.

Sex - a short and unbelievably easy how-to-guide

Doing the Locomotion

Sexual intercourse is sometimes called making love, having sex, fucking or having a shag. It is when a boy's hard penis goes inside a girl's vagina. Sexual intercourse between a boy and a girl starts with them both getting sexually excited. This is sometimes referred to as foreplay, and might involve kissing and cuddling, touching each other and other sexual activities. Foreplay is important as it means a girl's vagina begins to get moist and a boy gets an erection. If the girl's vagina does not get moist enough, then having sexual intercourse could be difficult or painful for the girl.

After the condom is on, the boy or girl can guide his penis into her vagina. The couple then move their bodies so that his penis moves up and down inside her vagina. This usually rubs the penis and makes the boy sexually excited so that he has an orgasm. The movement might rub the girl's clitoris too so she can have an orgasm. But this depends on the position the couple are in when they have sexual intercourse.

If a girl is sexually excited and relaxed the vagina will probably be moist enough for a boy's penis to go in without hurting. The vagina is very stretchy and, if a boy and girl have sexual inter-course, usually only part of the penis is inside the vagina. The average penis is between eleven and eighteen centimetres long when it is erect.

Acrobatics

There are quite a lot of different positions for sexual inter-course. One common way is for the girl and boy to be lying down, face to face with either the girl or boy on their back. If the boy is lying on top this is often referred to as the mission-ary position. Another way is for the girl and boy to lay on their sides with the boy behind the girl. If the boy is behind the girl the penis might not rub her clitoris and the girl or boy can do this with their fingers.

The big O

Similar things happen to most people's bodies when they have sex - they get sensitive and warm and excited and may have an orgasm. Enjoying sexual activities with another person is possible whether you have an orgasm or not. Not being able to have an orgasm with another person doesn't mean that you don't fancy them or love them. Your emotions might be dif-ferent each time you have a sexual experience depending on the circumstances. Having sex can be one of the most intense and pleasurable physical and emotional experiences a person can have. But it won't always be wonderful.

When sexual excitement builds up and reaches a peak a per-son might experience an orgasm, also called a climax or com-ing. The sexual excitement might be through masturbating on their own, or through kissing, masturbating or having sex with another person.

Sexual excitement usually grows gradually and a person feels more and more pleasure and a kind of exciting tension. All the feelings of tension then disappear when the orgasm happens, and the person experiences feelings of intense pleasure. The feeling can be so strong that a person might not be able to see, or hear or think about anything for a moment. They might even groan and call out with the pleasure. Orgasms usually last only a few seconds but the feelings might last a lot longer.

When a boy has an orgasm he ejaculates. This means that sperm mixed with semen comes out of the end of his penis in a sticky white fluid. After a boy has ejaculated he loses his erection and usually needs to stop for a while. When a girl has an orgasm her vagina often becomes very wet, but she can continue being sexually aroused as long as she likes. Some girls can experience more than one orgasm without stopping.

Sex can last any amount of time. A boy might find he comes very quickly the first time he has sexual intercourse. Usually sexual intercourse lasts longer as people get more experienced and know what to expect. But with a new partner it can take time for people to get used to each other. Also every time people have sex it is different, depending on how they feel and what they want.

Some people do make noises when they having sex. They might moan or groan with pleasure or even cry out. Some people talk to each other. Others don't speak or make any noises. But your body might make noises that you can't help - squelching and squishing. These might be embarrassing or funny, but they are perfectly normal.

Some people have sex once a day and others once a month. It probably varies for most people depending on whether they are in a relationship, how busy they are and how they feel.

The O-ral

Oral sex is when one person licks or sucks another person's penis or vagina. When oral sex is done to a man it is sometimes called a blowjob. When it is done to a woman it is sometimes called licking out. If two people have oral sex with each other at the same time it is sometimes called a 69 because of the shape their bodies make. A girl cannot get pregnant from giving oral sex to a boy, even if she swallows his sperm.

Oral sex can be a very intense and intimate experience. Some people enjoy giving oral sex or having it. Other people feel uncomfortable about the idea and don't want to do it Sometimes people feel pressure to have oral sex when they don't want to.

Cnods

Use condoms for protection against pregnancy or infections. Condoms should be put on the boy's penis as soon as he gets an erection. Some boys say they worry about using condoms in case they lose their erection or have difficulty putting the condom on. You could get some condoms and practice beforehand. Condoms come with instructions in words and pictures which show exactly how to use them. If you are going to be riding the bike, wear a helmet.

Love yourself

A girl usually masturbates by rubbing, stroking or squeezing on or around her clitoris. The clitoris is the most sensitive sexual part of a girl. A girl might touch her breasts too. A boy usually masturbates by stroking or rubbing his penis. Especially round the tip which is the most sensitive part. Masturbation is sometimes referred to as playing with yourself, or, especially with boys, jerking off, a hand job, or wanking.

People don't necessarily begin masturbating when they reach puberty. Some people hardly ever masturbate, and others masturbate a lot. It varies according to how a person feels. Some people masturbate when they are in a relationship with someone. Masturbation can last as long as you want, but generally people masturbate for between a few minutes and half an hour.

There is no physical reason why you should or shouldn't masturbate. It is not true that you'll go blind if you masturbate. It is not possible to masturbate too much, but you should stop if you start to make yourself feel sore. Some people think that if a boy doesn't masturbate his testes will fill up with sperm. This is not true; the sperm are just absorbed into his body. It is also not true that girls who think about sex or masturbate are 'easy'.

www.nicotext.com

BLA BLA

600 INCREDIBLY USELESS FACTS

SOMETHING TO TALK ABOUT WHEN YOU HAVE NOTHING ELSE TO SAY

BLA BLA

600 INCREDIBLY
USELESS BUT FANTASTIC

QUOTES

ONLY QUOTES FROM COOL PEOPLE!

SOMEONE TO QUOTE WHEN
YOU HAVE NOTHING ELSE TO SAY

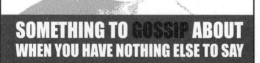

BLA BLA

600 INCREDIBLY USELESS FACTS ABOUT CELEBS

SOMETHING TO GOSSIP ABOUT
WHEN YOU HAVE NOTHING ELSE TO SAY

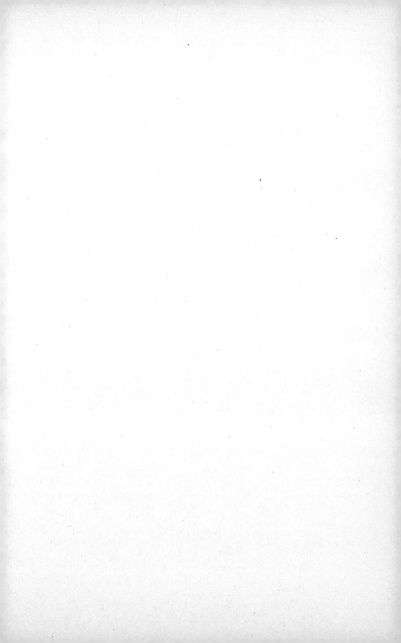